A LESSER LOVE

E. J. Koh

A LESSER LOVE

Pleiades Press Editors Prize for Poetry Series

Warrensburg, Missouri

Library of Congress Control Number:
ISBN 978-0807167779

Published by Pleiades Press

Department of English
University of Central Missouri
Warrensburg, Missouri 64093

Distributed by Louisiana State University Press

Cover Image: Adam K. Glaser

Book design by Sarah Nguyen
Author's photo by
First Pleiades Printing, 2017

Financial support for this project has been provided by the University
of Central Missouri and the Missouri Arts Council, a state agency.

Table of Contents

Love

Acknowledgments

SHOWTIME

Something I say beforehand:
Jal butak hapnida.

This translates into, *Please be kind to me*
but it suggests:

Even if I shame myself,
please be kind to me.

In the mirror, it means:
Even inside my greatcoat

of conscience, drunk and white,
please be kind to me.

HEAVEN

CONFESSION

Under my showerhead, I drink
the water to feel full.

Faking the still, there are little
footsteps over my footsteps.

Gishin. Ghost in Korean.
Sohn. Hand.

I have never told anyone
everything.

Older now, I must dress myself.
You cannot pity a baby.

Like innocence and fat
I have never been on time.

Before willfulness, I ate stucco
dropped from the ceiling to my face.

I started to tell stories because
my parents lived so far away.

TO MY MOTHER KNEELING IN A CACTUS GARDEN

For a month I tried to think of what to say.
How many times you've swept a kitchen knife
across your neckline and said, *This is how
you end a marriage.* How many more wicks you light
for God. I could tell by your eyes you've never

seen him. What would you call the feeling
of abandon and caution and relief that keeps me
tethered to you? Let me be the husband
you prayed for, the son you wanted, or mother
who held you. I'll build your new patio swing

and fold your coffee linens, wash your hardened
feet in warm water. To me, you have become a prison
of its own light. I'll grow greens and the parsley
you love and wrap them into cold sandwiches.
I will place them where you can reach with ease.

FISHBOWL

Four boys abducted a Japanese girl named Junko.
They beat her with an iron bell and set her on fire.

I wanted to say I was different. But I was curious once, angry.
 I thought I could kill.
I reached for a bowl of minnows to smash against the asphalt.
Before I could, my father sitting across the table snatched the bowl
and emptied its contents into his mouth—for humor.
 When I asked why,
he held my hand, pulling my arm taut, *When I had you, just a baby,*
held you in the air like this, I couldn't tell the difference between you and the sky.
And the part of me that was violent, pretending, unnoticeable, lit up.

1807 OLEANDER

At night, as Mom had, I rubbed
my wrists with ginkgo lotion.
They rested by my face
and I fell asleep smelling her.

Each morning in my garage-home,
I boiled salt water with pepper sauce,
used the same chopstick to stir.
I drank it.

Since I had no phone, she shipped
kimchi packets that ripened on the trip.
She sent letters from Seoul;
I signed the postal slip on tiptoe

and set them aside—her folded slip
with foreign squares, short crosses,
stops, points—
crowding the page, covering the creases.

SOUTH KOREAN FERRY ACCIDENT

276 Dead (232 Students)

28 Missing (Underwater)

1 Rescued Found Dead (Suicide)

Search operation is still ongoing.

Footage is released to the public: the captain
abandoning the ferry in his underwear. Barefoot, he jumps

into another man's arms. On screen, his face is purple.
He knew the ferry was 300 times over capacity, they say.

He knew the lifeboats were broken, the cargo was tipping.
After the footage, the ferry owner's son disappears.

The captain is charged with murder. A senior official
of the inspection company SeaTrust is arrested.

I once took the same ferry route between Incheon
and Jeju Island. The decks were green.

The students heard over the speakers: "Do not move
from your present location and stay where you are."

My parents are crying in the other room. "Why
didn't the students jump into the water?

Americans would've jumped." My mom is saddest
about the moment of drowning.

They're 15 years old. At that age, I believed in God.
Who says love that is painful is not love?

For the first time, my mom says to me, "Korea was wrong.
My country did wrong."

The mother of a deceased boy dove into the ocean.
The officers fetched her out, and she appeared on television,

saying, "My son is in that dark and cold water."
A volunteer committed suicide. The prime minister stepped down.

The South Korean TV stations ban music, variety shows, and games
for 3 weeks. My mom wakes me

in the middle of the night. "If you are on a sinking ship," she says,
"Don't trust anybody. Don't listen to anybody."

During a memorial service, a pastor who witnessed the cleaning
and shrouding of the bodies said, "How much the students must have

scraped at the walls while trapped in the ferry that their fingernails
have all fallen off." The chapel broke out in tears.

More footage from inside the ship is uploaded on YouTube
under the request of parents of the deceased student.

The footage is broadcast. The faces are blurred.
The voices are changed. They are laughing

for a brief second of nervous excitement. "Do you think
we'll become famous?" someone says, "Like the Titanic?"

A-802 ADENA LUCE

My new room had blushing walls and glow stars
stuck to the ceiling with wet rice.

She had put a pair of socks on the nightstand
so I would feel

I had been there yesterday and pitched them
to the floor. Cleaning, she would have

picked them up, flipped their ankles and left them
by my bed. I wouldn't feel the foreigner. My mother

wouldn't worry. From the hall, behind the door,
I heard, *Do you eat fish?*

FLOATERS

He pointed to himself and then to a patch of weeds
to show the difference between Man & Plant.
He gestured at the space between his index & thumb,
and said, there has to be a middle point, which would be Animal.

In order: the root & the fox & the infant.
He looked at me then and said,
I will not live to know
if there's a room between Man & God.

Then the sound of his oil lamp swinging and the wildflowers
(which die & grow over their own clusters) move closer
to his log steps, which he could not climb now
without the aid of a cane.

He asked me what floaters looked like, something he thought
his old mind couldn't notice. Once we were outside,
he said, *Ask me what the shapes of Angels looked like then.*
He recognized the clouds he had seen as a boy.

656 SUNNYHILLS

Mom had picked up another night shift.
If things got worse, she would have to go back.
Grandma was staying with me.
I got to eat food samples and skip naps.

We had gone to the Lion Market where we watched the butcher
oil up duck hooks in the window.
I tried Vietnamese coffee and ran into the street
and bit unwashed tomatoes from a pot of soil.

Mom stopped by between jobs. She always washed my feet.
Tonight
she asked Grandma to do it.

ANTTI REVONSUO

I.

The paperboy brought his baby
brother to watch the concrete liquid
slurry out the truck chute into a wellbore.
They held each other and died—
head bowed and spine bent.
A hunched, sexless figure wrapped copper wire
around their ankles, rolled them into the hardening pit.
The cement rose to the top of their heads. You said,
We've all had that one. Go back to sleep.

You drove me to the post office,
reminding me to recline my seat and lick my stamps.
We passed the newsstand where you pointed out
two boys, the ones I'd described,
both alive, eating chicken bakes.

II.

The boys have uncles and cousins that come looking—
the milkman, the clerk, the caddy, the clock maker,
and, with each one dead as soon as they are named
by the same demon, the list grows closer to our block.
Why I remember the pitch of taut wire, fumes of slag and sand—
I want to keep this to myself.

III.

In articles on dreams, I read about:
Americans waking nude, a mouthful of chipped teeth,
sun symbols, Bible verse, different words for *cricket*,
like *costly* in Korean or *courage* in Chinese.

It made everything common, harmless,
the way you said, *These things cannot exist.* I cannot
hang the laundry line without
counting ankles across it.
It is long enough to hold us.

43558 SOUTHERLAND WAY

She had hit her forehead on the fridge handle and opened a vein.
I cleaned her up. On the chancel stairs at the end of service, she asked,
Why do I live like this?

She jumped from the car on the turnpike and ran into oncoming traffic.
Three drivers veered to miss her.

We were almost back to normal, eating Spam omelets
on the newly painted porch, the smell of talc and mica mildly pleasant.
She scraped hers into a potted plant. *Anyone can make this fucking dish.*

INFERNO

I.

Watching a football game on TV
I always need to see the replay. You tell me,
*This is how God sees us. He knows what'll happen
but didn't make us miss the ball. Otherwise,
there'd be no justice in punishment.* On Earth,
you're smart and comfortable, abled by faith.

II.

I'm the child who shakes her head
crying in the hallway for whoever can hear.
You are the father, concerned, swearing
I know what I've done—
to confess like yourself, a brave person.
You tell me I've turned away from hell.

III.

I watch you take a black marker to the board.
You trace large circles spiraling down. We're arguing
if these rings in hell are just or if our souls are now
at ease with dying. You draw hornets and talons inside.
We sit and don't speak to one another. Noon walks in.
The air goes warm. Sunlight passes the ledged door.
You say, *Isn't this the sweetness we both want?
If we prove hell, we can want heaven.*

INGREDIENTS FOR MEMORIES THAT CAN BE USED AS EXPLOSIVES

I am not sad anymore; I am on the rooftop of my life
cheering until my body of hallways opens, jade and steaming.

When a pope dies tradition says to hit his head with a silver
hammer 3 times to see if he's alive: *koong koong koong koong.*

I've been so many popes. The shells of laughing are cooked.
Open the door and let them know I am not sad anymore.

Not once carrying my lunch pail soul with bright green fingernails—
Can a soul be excited to tears? That's the one time a soul is excited.

I am together—feel my forehead—I am young,
but I always forget what I meant to say; except I am alive!

And I will not jump from here because the wind is coming.
It has a beak and a tooth and has heard I am not sad anymore.

MY FATHER THE MUSICIAN

Even now my father plays his guitar inside his breast.
It was troublesome at first—

packing it away like pickling cabbage. He rinsed it in wine
vinegar, mustard seed, and peppercorns.

He quartered the tough outer leaves and grated the stem.
Now he gathers his body and bows before bowing.

He lies down a commoner and hands himself to the bed.
This is the chorus of godliness or decay.

In the pockets of my father's work clothes, his hands
are mice running the wire wraps. But when I look at him,

from my periphery, I see the ghost in him strumming, preserved
in its brine. Tell me what you wanted.

GHOSTS

always sit in swivel chairs that won't fit under low desks.
A fireplace log shifts
and the center leg of a table sinks without sound.

You can tell a ghost is here when the dog sniffs plaster walls,
or your left elbow itches, or windowpanes
bend where the sun hits.

Just now the staircase called out, old wood rasping.
A ghost has drifted in and he
settles like dust with nothing to gain or lose,

a sculpture in a museum—
until headlights cast beams across the ceiling,
bursting the shadows. If I say

ghost out loud, he will hover over the vacant seat at the table,
a voyeur from my past. No wonder
I enter my house like a visitor.

FATHER IN HIS OLD AGE

There is a Korean belief that you are born
the parent of the one you hurt most. Watching
my father use chopsticks to split chicken katsu,
he confesses that I may be the reincarnation
of his own father. We finish our waters in silence
and walk home chatting about who to blame
for where we are. He says, *The present is the revenge
of the past.* Revenge goes too far, I argue. And
in our unhappiness, we both want to know
we cannot pay enough. Pain becomes meaning.
After this life, I fear I'll never meet him again.

FIVE CANTOS

I.

My body is nobody.
My skull is nobody.
My eyes are nobody.

I wake nobody.
I sleep nobody.

Happy is nobody.
Suffer is nobody.

II.

Little and nearsighted, one living thing.
Then the dead in caskets underground
like gas pockets in rising dough.

III.

Nobody looks for an incision at the mountaintop.
Nobody is a prophet here.
A dead whale floats, and gas-filled, explodes.
There is food now.
There is sleep.

IV.

Nobody is language.
Nobody is a pink lake.
Nobody is the sun.

V.

Remember the human light is borrowed.
Flaming spectacles to wear on the face.
I am sorry to leave.
Even the youngest brain glows.

Nobody's universe, I see you
suspended between lashes.

I love this terrible nobody of shadows.
The cold goes out, pronged and starskinned.

SHAMAN

If you want to take
up space, first see

how small you are
like rocks, honey-

combs, and charcoal
anchoring, feeding,

heating. In the sky
the clouds are combed

like rabbit fur. If I
remember this, I am

not dreaming. You place
the flowered twig

behind my ear, mark
of my learning you

in bluebell, a person
small like me, but higher.

WAR

KOREAN WAR

You are the North and I am the South.
My tanks aim for you. I shoot you a thousand times.

Your missiles launch into my oceans. You raise monuments to scorn me.
You eat clams cooked in gasoline.

I drink milk and cider. I raise skyscrapers of businessmen.
You build towers of empty rooms. You refuse me from where I am most loved.

I clean a wintermelon of its guts and seeds cling to my wet fingers.
Aren't you the North, and I the South?

Phantom, disease, you're trembling. There is no patience in my country.
There is no safest place in yours.

The heart stiffens at the sound of church bells. I wonder where you sleep now.
You are the North and I am the South.

I cannot see the sky beyond the ceiling.
I cannot forgive you for cutting me out.

 I see all my ground, and you, walking over me, before you were
the North and I was the South.

A photographer captures a mass execution on film.
Men and women tied to posts, blindfolded—Korean spies.

The man nearest to the camera fiddles with his blindfold
until it rests comfortably over his eyes.

ALL BODIES ARE

hauled off,
harried by raw earth,
holy,
wounded,
disrobed, both
him and *her* hard–pressed
against a rifle, or
a silver knife, hand-to-hand
on a straw mattress
or a foxhole,
his and *her* trenches,
warpath of *Banzai charge,*
the origin of the term:
A man would rather be
shattered jade
than a complete roof tile.
All bodies befall
humiliation,
hot stinging welts
open at the crotch,
offered to an altar:
overcrowded,
all-white, bleached,
salted by weeping dogs.

TESTIMONY OVER TAPE RECORDER

I am the youngest. I am 85 and yesterday,
I was 15 in a military station;
my friends each dying, one by one,
and now I am old and I will die, too.
Today, the military gave me money.
But I ripped it apart and ate it up.
The president said, *I'm sorry. That was*
war. I stuffed my ears with cotton
and plastered my breasts with gruel.
The historian said, *It was necessary,*
girls like me, for war, girls for war,
girls for boys dying in war, girls must die
for boys dying in war, we cannot be
sorry for girls dying for boys dying
in a war of dying, girls for war, girls for
winning the war. Is it true? Girls, with
dug-up bellies, told they won the war!

THE PIGEONS

Led by a soldier at four o' clock in the morning,
we rode a train that stopped at a military tent.

Twenty soldiers returning from the battlefield, drunk with knives,
entered my tent.

I was eighteen when I lost my womb.
The smaller girls cried, *Mommy, it hurts!*

After the medics left us,
the wounded soldiers needed morphine.

They grabbed my clothes, and cried, *Sister, please give me a shot!*

I was sorry for them.
I injected their bodies and they fell asleep.

Before they died, the soldiers said,
My wife, my mother, let's meet again at that shrine.

After the war ended,
I visited the famous shrine but there was nothing, only white pigeons.

PARADISO

He had charged at me across the swamp
with a razor blade bound to a stick.
On his body, we found a postcard
(nothing on it) and a photograph—
an old man carrying a bundle of orchids.
There was no sign of country or faith.
This man who barreled towards me while I
fired a machine-gun, he was running
across a field of orchids, carrying a letter
writing itself and he was, I know, racing
towards the whiteness of his glowing mind.

CARROTS & CELERY

That's what they told us—
> because the food was orange and green.

> Some carrots
> hadbones.

> One man found
> a moon-shaped
> nail.

But we were
hungry, we asked for carrots and celery.
> I got one hair in my carrot.

> They told me it came
> from the longest-haired dog in the world.

A woman refused to eat her carrots and celery.

> She died with a grin.
> She was hungry
> but she was not

> wrong.

RETROGRADE

The history book says girls were dragged
from their houses and tied to telephone poles

followed by *unspeakable torture*—what was not
unspeakable were the narrow prison closets

of forced prostitutes who bit their fingers
to draw the country's flag in blood outside their doors;

it was unspeakable that the officers carved
Butcher on their foreheads—girls hiding

knives because they've lost, but have not given up,
and tomorrow, I get the paper and the front page

talks about why Korean girls use plastic surgery
and white men, the title reads, "South Korea:

The Plastic Surgery Capital." *They put their money
where their mouths—and eyes and noses—used to be."*

TRILOGY

They tell me, *Go to sleep*. If they love me
they say, *Go to sleep* until I am a wide plain.
Go to sleep. Until the oh's are ironed into ah's.

Go to sleep, they say until I am a blue horizon.
Sleep until the milk is legend, left to wash feet
in the morning. Legend stops the rot of people.

There is no big bright word for leaving.
There is no rest so pained as I am pained by rest.
Sleep like a good, sharp knife.

TWENTY

Street lamps kick on and I'm the last to head home.
Dusk settles over the bare parking lot.

The cold pierces the skin like a syringe to a girl's arm,
a man holding her as the liquid sinks into her flesh.

I shift the stack of papers I'm holding and there is no point
in working late. The girl prays, her eyes wide, white.

The tip of my key, jamming into the car lock, fits in.
The man ties ropes around the girl's wrists to a bedpost.

Enough to keep her heart pulsing to find a vein,
she will be awake for a few more hours.

Begging for sleep, she will see a pike of lust
stretch the soul out of her body. I see the sky.

The first drops of rain slide down the windshield.
The girl begins to hum like the start of the engine.

MOAT

My recent ghost stands over me
in the form of a yard rake—little spine umbrella.
She doesn't say anything that terrifies.

I say to her, *Who are you to turn balm?*
Where are you taking your face?

Peaches appear beside mud.
Milk turns to courage for the poor.
Pain is 1, 2, 3.

I drop myself off at airport, hospital, shithole, baby
shower, hospital, airport, shower, hospital.

Her and her wooden mouth. She is sad
for me or there is more to be sad for after life.
The need now is a cooler one, a discrimination.

Ghost, if you ever murder me
I won't become a prison of my own body.

LEANING ON HEAVEN

I am twenty-four, stunning
and still alive watching the attendants
shut the compartments above, harder as they near
then disappear. No one is ever safe.

Going home? asks a woman
as old as the blue velvet covers of the seats.
The city creeps away beyond the windows.
Lying against the headrest, I open my hands.
Home is for people who are ready to die.

Not a minute after, the woman is asleep
with closed fists. Soon, she is gone like the rest
inside the cabin without the deepest sound
of the engine. I am weak
from missing what I know is gone.

PLEDGE OF ALLEGIANCE

I am the country of myself, liberty and justice
for all, and my country cannot apologize anymore.

When my mother tells me, under allegiance:

Be happy! When you smile happiness is chase you—
her language is a hand she lays on my head.

Time swings by the front of our lives and doesn't undress itself,
will not bathe itself. You cannot pity a baby for which it cannot stand

one nation, under God. The type of people I am,
300 million times over.

I pledge to the flag just-wet with jet fuel
from the Hubblescope of the United States of America.

Read the news: Protestor dies from fumes of burning flag.
Pistachios undergo spontaneous combustion. The grenade

hand-made from YouTube comments to the Republic
for which it stands, Jurassic Park, under God,

indivisible. Pick one for all. God is 65 million years away.
Looking into a telescope at Earth,

he sees dinosaurs. We stare at Mayan temples
and they are giant loudspeakers.

CLEARANCE

I browsed CIA.gov
for jobs:

> Targeting Officer,
> Intelligence Collection Analyst,
> Counterterrorism Methodologist,
> Librarian.

Be prepared to undergo a thorough investigation...

They found:

> I watched more porn than most women.

> I wrestled and, upon demanding
> an opponent two weight classes up, was
> publicly humiliated.

> I drank a cup of holy water at a wedding.

> I cannot hold my bladder past two hours, making me
> uneasy in the following places:
>> Subways. Banks. Bars, liquor stores. Boats.
>> Elevators, parks, outdoor malls, small offices,
>> beaches, buses, and waiting rooms. Funerals.

> I lied about speaking French.

> "How to disable a bomb" in my Google search history.

> I pass international customs with suitcases full
> of red meat, greens, and seeds into the country.

> No drug use in the past two years.

My elementary teacher asked why I'd try for the spelling bee,
and what the biggest word I knew was. I said, *Masturbation.*
She sent me home with a red card.

I lie to people older than me,
tell the truth to younger people.

A Davis high school baseball team bullied me,
flipping my chair and making squinty eyes.
I tried to choke one of them
and was removed from class.

I laugh at racist jokes.

I feel responsible for the death of my two parakeets
and my grandmother.

I never litter.

I was fifteen when a Korean hairstylist proposed to me
inside a McDonald's in Tokyo, Japan.

I danced for a Hip Hop team for two years
by whom I felt largely betrayed.

My mother worked a shopping mall cart and fainted
when a customer stole a sixty-dollar makeup kit.

I believe in God.

The CIA called, I
passed.

BEYONCÉ'S *SINGLE LADIES*
ENGLISH TO ENGLISH TRANSLATION

All the big beautiful women, bondage women,
divorced women, bisexual, transgender women.
All drug-free, gay, non-religious, Latter Day Saints,
social drinker, straight, widowed-with-kids women.

Look at the blue ceiling.
Dance because the ghost is gone.
Your husk was brutalized. It's gone too.
You've left the bear, the torpedo, the poodle moth.
There is someone else now.

The man is an almond in a bloom.
Don't touch his childhood.
3 years is not like a straw, it's a house.
Find liberty somewhere else.

You didn't marry the bear.
You didn't marry the torpedo.
You didn't marry the poodle moth.
There was no ring for you.
There will be someone else now.

Remember the blue light.
Remember the man.
You can hear him thinking
until he forgets who you are.
Call him the president of your body,
then show him how it must be
to be a president without country.

MY COUNTRY

I want to be immortal. Not as a star
but as an ego.

The universe is female. Walk me through the story
of a mother dreaming of a pearl and a tiger

when she is pregnant. She does not tremble.
She is a mountain stuffed with people.

Frenetic lure in proportion to a meteorite
in the desert that will turn into a lake

the color of finger lime. I look out at the continent
where a gorilla named Michael

knew sign language and described what it was like
to watch poachers kill his mother.

BLURB

They say the mother in my world has no pulse.
They say the god I talk about is not the god people fear.
They say the subject of race is no exception.
They say I have difficulty with the surfaces, the echoes,
 the sudden, the no longer there.
They say the shape of the crown on my head
 is only a narcosis of motherlessness.
They say I am cracked. I am no river but a lizard against a backdrop
 of oddly reigned and oblique conversations of people.

I am common, they say, a commoner.
I am a map of betrayal, of refusal to prick into our times.
I am no storyteller, only troubled.
I am not sad, nor inventive, nor magnetic.
I am forgettable man and forgettable woman.
I have done nothing more than create an angry reader with a sense
 that nothing is profound, all is meaningless.

I have no friends with cancer.
I have no career and no future.
I have no finest and most famous work
 that tells a story of a small town.
I do not live in Nebraska, Montana, or Michigan.
I was not born in Colombia with a prize for literature in 1982.
They say, deeper and deeper, I prove there is nothing in me
 hard-earned or spiritual or broken.
They say I will never have enough to lose.
There is no judge, nor critic, nor author, nor poet that is my friend.

There is no great enterprise in my life.
There is no cult of personality.
There is no exquisite tension
 created in my deftly stiff juxtaposition of images.
There is no death like the death of expectations after I dare to rear up
 and ripple language against the innocent pressure of readers
 that must compromise nature itself to look upon me.

There is no exuberantly constructed richness in my speech,
 my speech so unsophisticated in its use, a betrayal
 of literary traditions from the language of the Bible to Faulkner.
No words of mine should be required for the entire human race.

My real gift is for my exceptionally non-diverse work.
My words are the most unenticing choices of our century's literature.
My words punish the reader. My words do not convey sincerity.
My premature, debilitated, crippled words
 without meaning of drama or self-discovery.
By calling my words poetry, they would be denying
 its considerable failure as words.

I am irresistible to flies.
I am lame.
I am ugly, sometimes, achingly so.
I am challenged, narrow, and dull.
I am never a delight and never full of lyrical variety distinguishing
 a rich tradition of allusiveness.
They say I am an artist that fails both a private and national heritage.

They say I am not funny.
They say I am tasteless.
They say I am a fugitive.
They say I am disturbing.
They say I am descending and disorienting.
They say I am a box of pins.
They say I am an intimate world,
 incoherent, private, and unrelatable to culture.
They say I write from a common sensibility that no one can admire.
More than poetry, they have tried to find something human in me.

$$6CO_2 + 6H_2O \text{ light} \rightarrow C_6H_{12}O_6 + 6O_2$$

I am trying to make an equation to convert light
into reasonable dioxide.

Put your fist like a rock over your chest, say:
I am ahead of the future if I am a kind tiger
swimming underwater. I'll live in a little river
house because I am really a scientist.

If I am an alien, then families surprise me most.
Biological lottery: staying with whoever bore you
or whoever was born of you. Primate: hoping
you don't dislike those you meet/are lucky not to.

$$\text{Person depressive} + \text{Person angry} \rightarrow \text{Person suppressive}$$
$$\text{Person suppressive} + \text{Person happy} \rightarrow \text{Person liar}$$

You've ruined it Mom and Dad. You've evolved
humankind into liars. 4 billion years should have
photosynthesized reason and your crapulous genes
to liberate a good person. Good people:

When you see one, then see them everywhere,
it's called the Baader Meinhof phenomenon. Sounds
like a baseball player with a gun; or a dead person
the color of cooked chicken; or quicksilver.

I don't want happiness to chase me. I want metallic
blues in miscellany. You don't want to calculate
your molecular life: you want to be overwhelmed.

TIGER BALM

Yellow pears, basketfuls, relate to distance
between the you and the me – *mu.*

Startling up as you walk goosefooted
through my door, I am heavy.

I feel the continent under me. I am 99
percent hydrocarbon.

Through me, the cosmos can look at itself.
Come to the sink. Let me wash your feet.

Why do you call me embalmer
when my job is time mechanic?

Come with me. I know which home takes the turning,
which mind washes in hot water.

I am the shelter you need,
needle-threaded with the truth of dark wood.

LOVE

LOVE APPEARS IN THREE LINES

A boy danced. He was the Buddha.
At night, he shape-shifted into two rivers.
I stole into him, then drowned.

VALENTINE CHAPTER

I tell you there's a devil in my wall. You ask,
Does he like Spartacus?

On Showtime, we watch the part
where Glaber murders his wife's father—

I ask, Would you kill my father to have me?
Of course, you say. This minute, you smell

of red ginseng. I ask how you could be with me,
How could you forgive me; I can't change.

You look up and say, *I am patient. I can take the lives
you couldn't live and hold them in my arms.*

HOW FEAR WORKS

I miss your car
speeding,

the quick turns;
crack of my head

against the windshield,
the empty bed,

a disgusting
spot of blood

on my underwear
growing overnight,

the kindness
of breakfast ready,

the word: sorry—
I'm sorry about

the broken plate,
swept-up glass, or

the soccer game on,
your big red face

clarifying, don't
run I'm angry

at the goal keeper
not you.

ICICLE CREEK

1.

Undressing an orange from top to bottom, I want another child
—that man's child. He squats under a tree with a folder, too busy
to tend to anyone but papers, comforted by page after page.
He would discover me washed ashore inside a chest stuffed
with love letters, each one containing a knife with no instructions.
Now I ache for rude, sturdy things like his thick muscled calves.

2.

At night inside a hut, an argument rises between two men
about who will have me first:
> *I will have her because she doesn't fear me. I bring her pleasure.*
> *No, I will have her because she depends on me. I lead her.*
> *I will both times, the first for me and you. Because I can.*
> *You do not love her. What is your purpose of lying with her?*
> *We are pretending to be human.*
I call out from the earth. My voice—hoarse, crumbling:
> *It doesn't matter. I will have monsters, monsters for husbands,*
> *then monsters of our own making.*

3.

I give birth to a boy and girl. I don't know which child
belongs to which man until they are old enough to curse me.

4.

I am the daughter of a demigod and a hunter. They lived
on Jeju Island. I visited once. Trash blown by the wind
through howling cave tunnels, tangerines floating in the bay,
volcanic rock walls shaped as if people were trapped inside.

I am a cave of people—first of husbands, then my children
who fight. I tell them to stop. *Fight your fathers instead. Be angry.*

5.

It's unnatural to see the tears of my children, husbands,
and then mine—all collected on the roof of my house.
Give me the shovel. I will go out into the field to bury
what makes us cry. Bring me salted tilefish we can eat.

6.

One husband leaves. He is tired of us. He goes alone.
The other husband is jubilant. He wants another child.

I abandon them and the children. I hike through
a mountain pass and arrive at a German town. A brass band
plays folk music outside. I walk into a mineral store.
The first stone I see is a sheet of basalt. An old man appears.
He turns to me and asks, *How much will you pay me to eat this?*
I tell him, *I don't have money and I've already killed before.*

7.

In town, I meet a fox wearing a blue shirt.
He invites me to join him in a hammock
he pitched between two boulders in the forest.

We sway off the boulders jutting off a ledge.
When I leave the hammock, I am pregnant.

The fox asks to take the baby for himself.
When I refuse him, he follows me until I give
birth under the bough of an olive tree.

He takes the baby. For fifteen years, I chase him.

Looking for him, or looking for the baby.

8.

At Icicle Creek, I find the fox dead and gray.
I see a woman standing over his corpse.

Her tail whips behind her, stirring air.
I pray to be harmless.

9.

Looking at the woman, I see all my life as hers.
There is no such thing as alone. I say to her,
One day, you will give up everything. No one will know you
—because of this, how beautiful you ought to be.
She breathes: joy and ease, joy and ease.
Everything born is ready to become an answer.

THIRD NIGHT IN THE DESERT CAVE

You are the peregrine falcon. You are the wide-open sky it flies through. For the first time I call you by listening.

MADRONA

You are a bouquet of roses—
astonished, your face turns

towards modesty. You might say,
Stop writing poems about me.

But you leave twice,
something that rises slowly.

If I can own anyone
I ask for none

unlike orchids that cannot
grow unless paired.

Orchids choose to be plural.
What to be told,

I don't know.
I remember you loved

to swim. Everything I am
becomes water.

My eyes become lakes and lakes
somewhere gather.

Grief washes through me,
this over-calm.

DOOM

A man who drinks between my long white columns
tastes history: the first time I touched my breasts,
then changed into an ocean from a dam—

my belly a sculptor of people, fed by the milk-springs
of my mountains. The smell of coins mixed with something
sweet like corn, metallic savory of the hard youth I lived

washing my stained underwear in a bucket on the street,
hanging them on lines that rocked over my head—a nursery.
The coloring both lightest pink and hardest rose, freckled

where women of my family have freckles. The shade matching
the sort of my lips. When my mouth is dry, I too am
elsewhere. How about the shape—the suckle, the cinch, the prissy,

pretentious and shy until held by the eyes? Soft
as the bottom of fruit, bruises—hairs like the hairs inside a bite
of mango. A man who places his ear on me hears the roar

of his blood surging through him. His tongue speaks
until my own speaks the same cooing language.
We must enact what it means to live off one another.

AFTERWARD

I.

Summer in the office, my son warns me,
You can't want to die.
You're either dead already or living.
Pick one or the other.

I look at him and he is the other.

II.

I pray by the chancel stairs.
Nothing here but the floor marks
of a missing statue, absence
staining the boards, the votive candlewick
barely burning, but burning.

III.

I always dream, pushing my hands
into my coat pockets. Cold fingers
nip the lint of my childhood.

IV.

Cooking without knowing
the chopping board will splinter
if I run my fingers against the grain.

With one cut I pry the spine
from a dead fish and leave its shivering eye.

SLEEP

There is always too little. The tea-stained tablecloth creases
where my hand rests. My head wilts. I sit and sit (my body
grows over the hide of the chair). To me, it seems the body
knows what it is to forget. Aroma of apple and figs and a memory
draw blush from my cheek. Not unlike the time I watched

the wind going and going, and taking with it bellyfuls of millet.
My mother in the other room is stirring a saucepan, making
round sounds. I lived unaware of how the stunning bird offered
herself to the bluff. Her milk-wings, umbrellas, folding.

On my left, a breeze drums the padlock. The fruits roll
onto their softened sides. I hear booted mudfeet at the door.
Ants cross water. The knives tune themselves. The jug
(open with its handle bent on its high hip wants to say
something about seeing truth). I am sick in my own way.

THE WATER

Homemade filter: an inverted barrel packed with charcoal,
sand, and charcoal. Pouring in mud, clean water weeps

out as virtuous as faith and the color seafoam green.
I made a killing so I left the city to live in a forest.

The sacred freeway is faraway. I must live one more month
and die not a second after—this attaches happiness.

If I could speak to God, I'd confess, *I never meant anything
I said.* Someone must know I tried to be unhardened

by the halo of human fear that is acidic and constantly won.
I recall the waft of cooking rice. I watch my overturned self

like I watch someone on video inject hydrogen peroxide
into a tick full of blood. Love opens out like tigermelon.

The memory of a house: I am hungry for food as I am
for someone to appear. I wouldn't kill myself to prove

the after-life exists. Whether it did or did not, you would
never hear from me. I'd become a warm weight, a world.

THE WIND

The poor wind returns from the mountains,
passes through the door, and lights up around the fire.

It wishes it were smaller—to be held.
It wishes it were heavier—to stay when it pleases.

Outside above the lake's mirror
the wind tolerates its own placid face.

The wind traveled from a farther past.
The wind today has always been. Purposed to lean in

as close as it will never touch.
The wind mourns by rattling windows and rustling trees.

Don't leave me, the wind says, unwed.
The wind is alone in every measure of aloneness.

The wind is something to be left behind.
If the wind were a woman with arms and legs,

she'd be too light to weigh on anyone's mind. She'd say,
if one life were born again, let it be yours not mine.

THE MOUNTAIN

She protects silence. She communes with it by sitting.
She holds onto it by giving up endlessly.

She gets bigger, smaller. She feels burdened by effort
—by distance crossed by the dark.

She takes comfort in doing nothing.
She loses her own importance. She believes in defenselessness,

then lightness. Deep in her heart, she waits for the end.
She tows in time; earns her breaking.

No one knows why she weeps as bright as memory.
When asked, she says, *The end must come first.*

THE FOREST

I wander into the forest to bathe.
I find the noise required to find silence.

My soul seats itself for the first time.

Where it is quiet, it wants to be cold.
There is nothing I must do but die.

What a joy to let go of all things.

When you ask me the question
your life was born to answer, I point—

what joy to give up—

to the sky we depend on for its blue face
to turn when you turn unto silence.

PRIEST

Masonry-walled with thickset
 limestone in the lowland jungle. The length of the granite bed
says he was a tall man, and the sole headrest suggests without family.
 Steps waist-high show his strong legs.
The carved, triangular altar—where he prayed.
 Harpy eagles and howler monkeys flank the window.

No one lives here anymore. The roof fell in,
 and fires cracked the blocks like chipped teeth. Hosts of temple-men,
master-builders, potters preserved by ash beneath corbel arches.
 But one painted, wooden beam held on to its ivory-white.
Centuries have eaten its bristled rind. Hidden
 under this canopy, half-covered in roots and earthwork,
the wood wanes in its own lifetime.

HAPPY

—for Adam

The sound of a poem—it starts with the footsteps
of an ant over the log we sit on. We hold up steaming mugs
and we commit our anxieties to the air, for these anxieties
to become air, warmer and fresher as they rise away.

The prologue prolongs the holy word—light.
There is light eschewed from our bodies—in all places,
a source of its own, highlighting our features with pale
observable lightness as it does to breasts and breath.

The middle begins with rocks falling off a cliff-face
into the water. This is the argument against time that passes
through our bodies, sinks to the bottom of what used to be,
raging at the seconds, sweeter and more stale as they leave us.

Crisis is shaped like an owl pellet we open together,
the tiny bones, beaks, and fur. There is a little tooth, a puff
of feather. The further we peel back the translucent layers,
the more heaven is dimmed by our bright and curious joy.

The solar system is a clock. It turns as we pull
the tulle, leave the linen, divide the diamond, christen
the chrysanthemum, circle the Sound—as we, ourselves,
pull back into solace. We are witnesses of each other.

Afterword, we are unconcealed. Soon there is no
difference between words, and then things. We are beginning.
We are elliptical. You ask me across the aisle of the market,
eating your croquette, "How can you make a poem happy?"

ALKI THE TOWN OF DREAMS

Facing east towards water, a dozen porch benches
overlook an isle of skyscrapers; but nearer, a strip

of gray beach sand, a pier house selling hairy muscles
each second, then one long hour of bike rentals riding

a mile of fresh gravel laid to rest beside the docks.
On the street, a song plays about mermaids kissing

whales whose underwater tears transform into pearls
after twenty-seven years—plus, today I am one whole

pearl and the first dusty form of a second sinking into
the ocean they call home. Car roofs roped with cases:

bookcase, pillowcase, suitcase. This town writes all
lowercase across its paper signs and copper plates,

whipping at the suggestion of wind. This place fits zero
room for excitement. It calls forth nothing but restful

silence and ease. The doorways are hubs decorated
with string lights. Through one door, a man approaches

as casual as a bird sailing into its fullest wingspan
towards me, as if he'd been there since the beginning.

ACKNOWLEDGMENTS

My thanks to the Jack Straw Writers Program, Kundiman, The Mac-Dowell Colony, Napa Valley Writers' Conference, and Vermont Studio Center fellowships for helping me complete this book, and for these journals where my poems first appeared:

Apogee Journal: "Social Equation" and "Jesasang"
Berfrois: "Clearance," "Blurb," "Happy," and "South Korean Ferry Accident"
Berkeley Poetry Review: "Mountain," "Wind," and "Love Appears in Three Lines"
Blue Lyra Review: "Division" and "A-802 Adena Luce"
Boston Review: "Icicle Creek"
Boxcar Poetry Review: "Leaning on Heaven"
CityArts: "Shaman"
Columbia Review: "My Father the Musician" and "$6CO_2 + 6H_2O$ light \rightarrow $C_6H_{12}O_6 + 6O_2$"
Entasis Journal: "656 Sunnyhills" and "Ghosts"
Gulf Stream: "Liquor Store"
Hot Street: "Floaters," "Valentine Chapter," and "Showtime"
H.O.W. Journal: "Beyoncé's Single Ladies English to English Translation"
iArtistas: "Ingredients for Memories Used as Explosives"
James Franco Review: "Doom" and "Korean Art"
La Petite Zine: "Afterward"
Midway Journal: "The Pigeons," "Retrograde," "All Bodies Are," "Paradise"
Narrative: "Tiger Balm" and "Moat"
No, Dear: "My Father in his Old Age"
Nostrovia Press: "To My Mother Kneeling in the Cactus Garden"
PEN America: "Testimony Over Tape Recorder"
Pif Magazine: "Confession" and "How Fear Works"
Poetry Quarterly: "Floaters"
Print-Oriented Bastards: "On Sleep"
Qarrtsiluni: "Late-night"
Seattle Review of Books: "Korean War"
Southeast Review: "Fishbowl"
Susquehanna Review: "1807 Oleander"
The Journal: "Ruins"
The Margins: "The Forest" and "Madrona"
TriQuarterly: "Antti Revonsuo."

"My Country" and "Clearance" appeared in *Privacy Policy: The Anthology of Surveillance Poetics* (ed. Andrew Ridker, Black Ocean 2014); "Pledge of Allegiance" appeared in *Political Punch: Contemporary Poems on Politics of Identity* (ed. Fox Frazier-Foley, Erin Elizabeth Smith, Sundress Publications 2016).

The Seattle Channel featured "Blurb" and "The Wind" on *Art Zone with Nancy Guppy* for its April 2017 television broadcast, filmed and edited by Vincent Pierce.

Reverence for my readers I'm lucky to call friends, teachers: Timothy Donnelly, D.A. Powell, Don Mee Choi, Susan E. Davis, Marci Calabretta Cancio-Bello, Eamon Grennan, Mark Strand, Kirsten Abel, Colette Atkinson, Sarah Blake Schoenholtz, Greg McClure, Jay Deshpande, David Hinton, James T. Chiampi, Mary Szybist, Timothy Yu, Lucie Brock-Broido, and Eugene Gloria; and the University of California Irvine, Columbia University in New York, and University of Washington for giving me a place to write.

Heartfelt thanks to Kathryn Nuernberger and the Pleiades Press editors who chose this book for the 2016 Pleiades Press Editors Prize; for the University of Central Missouri and board for their devotion; for designer Sarah Nguyen and Adam K. Glaser for the cover; my support at Valve Corporation, the Richard Hugo House, the recipients of my Thousand Love Letters project, and my students, and my family: Young Geum Koh, Seok Ha Koh, John Chang Hyun Koh, Kae Hwa Kang, and Ari.

ABOUT THE AUTHOR

E.J. Koh's poems have appeared in *Boston Review, World Literature Today, TriQuarterly, Southeast Review, Columbia Review, Narrative, PEN America*, and elsewhere. She has received fellowships from Kundiman, The MacDowell Colony, Napa Valley Writers' Conference, Vermont Studio Center, and the Jack Straw Writers Program. She earned her MFA at Columbia University in New York for Creative Writing and Literary Translation in Korean and Japanese. She is completing her PhD in English Literature at the University of Washington. She lives in Seattle, Washington.

THE EDITORS PRIZE FOR POETRY

The editors at Pleiades Press select 10-15 finalists from among those manuscripts submitted each year. The director, along with a panel of members of the Pleiades Press Advisory Board selects one winner for publication. All selections are made blind to authorship in a contest in an open competition for which any poet writing in English is eligible. Pleiades Press Editors Prize for Poetry books are distributed by Louisiana State University Press.

ALSO AVAILABLE FROM PLEIADES PRESS

Novena by Jacques J. Rancourt

Book of No Ledge by Nance Van Winckel

Landscape with Headless Mama by Jennifer Givhan

Random Exorcisms by Adrian C. Louis

Poetry Comics from the Book of Hours by Bianca Stone

The Belle Mar by Katie Bickham

Sylph by Abigail Cloud

The Glacier's Wake by Katy Didden

Paradise, Indiana by Bruce Snider

What's this, Bombardier? by Ryan Flaherty

Self-Portrait with Expletives by Kevin Clark

Pacific Shooter by Susan Parr

It was a terrible cloud at twilight by Alessandra Lynch

Compulsions of Silkworms & Bees by Julianna Baggott

Snow House by Brian Swann

Motherhouse by Kathleen Jesme

Lure by Nils Michals

The Green Girls by John Blair

A Sacrificial Zinc by Matthew Cooperman

The Light in Our House by Al Maginnes

Strange Wood by Kevin Prufer

PLEIADES
P R E S S